TOO BUSY TO COUNT THE YEARS

Suzanne Snyder Jacobson

Suzanne Snyder Jacobson

**Andrews McMeel
Publishing**

Kansas City

Too Busy to Count the Years copyright © 2002 by Suzanne Snyder Jacobson.
All rights reserved. Printed in Hong Kong. No part of this book may be used or reproduced
in any manner whatsoever without written permission except in the case of reprints in
the context of reviews. For information, write Andrews McMeel Publishing,
an Andrews McMeel Universal company, 4520 Main Street, Kansas City, Missouri 64111.

02 03 04 05 06 KWF 10 9 8 7 6 5 4 3 2 1

Library of Congress Cataloging-in-Publication Data

Jacobson, Suzanne Snyder.
 Too busy to count the years / Suzanne Snyder Jacobson.
 p. cm.
 ISBN 0-7407-2242-5
 1. Happiness in old age—Quotations, maxims, etc. 2. Aged-Psychology—Quotations, maxims, etc.
I. Title.

BF724.85.H35 J33 2002
305.26'022'2—dc21

2001045911

I dedicate my book to my loving parents, Elizabeth Bartley Snyder and Milton Snyder, for giving me a strong foundation and the message that I could do anything.

I also remember those who did not have the opportunity to see my book published, but nevertheless inspired me at all times: my father, Milton Snyder; Marion Golden; John Bennett Jacobson; Eleanor Lakin; Esther Duffen; and Kay Bartley Greenberg.

FOREWORD

As we embark on our journey into the 21st century, the nation and the world continue to experience the challenges of a society that is growing older. Since 1900, the number of Americans 65 years of age and older has increased 11-fold, from 3.1 million to nearly 35 million. The older population is itself getting older. The segment of the population reaching 85 years of age and older is 33 times larger than it was in 1900. Persons reaching age 65 today are granted an additional 17.6 years in average life expectancy.

That is why Suzanne Jacobson's book, *Too Busy to Count the Years*, is so intriguing and enlightening. It focuses on the fastest growing segment of our older population, debunking the myths and stereotypes faced by this generation of people. A recent survey conducted by the National Council on the Aging revealed

that many commonly held beliefs about older people are untrue. For instance, people do not automatically retire at age 65. In fact, nearly half continue to work full- or part-time, and 44 percent over age 65 do volunteer work. Almost half of older people say these are the best years of their lives, and nearly all of those surveyed say they'd be happy to live to 90!

Suzanne Jacobson's photographs of octogenarians, nonagenarians, and centenarians are wonderful images that graphically dispel the myth that older people simply retire and go on to lead unfulfilling lives. This is a drastic and personally pleasing departure from her earlier work. I'm flattered that she credits me with inspiring her to seek out active older adults to hold up as examples of successful aging.

The Glennan Center for Geriatrics and Gerontology at Eastern Virginia Medical School in Norfolk, Virginia, is pleased to house a permanent exhibit of Suzanne's portraiture. Her exquisite photography and thought-provoking narratives about her subjects delight and captivate all who chance to come upon them while

visiting the Center. They showcase her rare talent and, more importantly, showcase our nation's older adults by sharing the richness, vitality, and beauty of growing older. A time that is full of potential, resilience, and courage.

John Franklin, M.D., M.A.C.P.

ACKNOWLEDGMENTS

I express my deep appreciation to my husband, Jack, for always encouraging me to pursue my passion; my children, Maryann, Carol, Jamie, Janie, and Betty for always cheering me on; and my granddaughters and able assistants, Claire and Alyson, the next generation.

My thanks to my agent, Aaron Priest, and to Elizabeth Shah-Hosseini of the Aaron Priest Literary Agency.

To Christine E. Schillig of Andrews McMeel Publishing.

To Barbara Kestenbaum and Emily Rosen, who set me on the path toward publication, and Brooks Johnson, curator of photography for the Chrysler Museum of Art.

To the following for valuable critiques over the years: Benn and Esther Mitchell, Dr. Bernie Siegel, Madeline Dunstan, Reba Karp,

Lorraine Fink, Dee Agostinoni, Barbara and Ron Shocket, Eleanor and Alan Lakin, Josef and Cecle Adler, Estelle Berman, Gloria and Hal Hoder, Judith Barr, Ilene Eder, Germaine Clair, Marian Leavitt, Paula Zinneman, Mark Atkinson, Sybil Berkley, my sister Barbara, and my brother Robert.

I have deep respect and gratitude for my teachers: Milton Snyder, Phil Morrison, Jay Pfeifer, Joseph Lust, Chuck Bress, Joyce Tennyson, Mary Ellen Mark, Arnold Newman, Mary Virginia Swanson, Harvey Stein, Anna Tomcheyk, Sandra Stark, Harry Mattison, the Palm Beach Photographic Center, and the Center for Photography at Woodstock.

My special thanks and gratitude go to Joanne Siviglia, my "right arm"; Susan Leichtman, my photo printer and friend; Allison Hoch, for interpreting; and Kevin Moffitt of WebFacade, my Web page designer.

My family and friends wrapped a web of support around me, and I'm grateful.

INTRODUCTION

I was about five years old the first time I saw my paternal grandmother, Nettie Snyder, using a camera. She had inherited my grandfather's photography studio and was determined to keep the business going. I watched her print and hand-color photographs. When the image appeared from the glass negative, I knew I was experiencing magic.

Forty years after my visits to my grandmother's darkroom, I was on vacation in Florida and took a photography class with Mary Ellen Mark, the photojournalist and author of *Ward 81* and *Streetwise*. A master teacher, she helped us to understand that photography is a powerful tool for storytelling as well as for historical record. We learned the absolute importance of establishing a relationship with our subjects and their living conditions.

One of our assignments was to photograph one place for one week with one lens. A nursing home seemed a natural place for me, since I always felt most comfortable and safe with older people.

Once inside the nursing home, I always asked permission before taking a photograph and was careful not to intrude on anyone's life with a flash. I treated my subjects with the dignity that is all too often lacking in their worlds.

I committed myself to this project with passion and purpose, all the time learning so much from my subjects. How individual they were! I observed how too often the elderly were treated with little consideration for the uniqueness of their personalities. Each day was a lesson in life for me as these people became my mentors and my friends.

After my first major show, a prominent gerontologist challenged me to find and photograph still-active seniors who were in the prime of their lives. I placed an ad in a local newspaper asking for volunteer participants for a proposed book.

My first response came from someone who taught me one of the most poignant lessons of that experience. Jack Lasky told me he was 98 and invited me to visit him and his wife at their apartment. And I, still not past the stereotypes, asked if someone in his home could give me directions. In a strong, assertive voice, Jack replied, "I know where I live. I can give you directions." I have never stopped learning from the people I photograph.

Some common threads are evident among the people in this book. Each of them has a keen sense of humor. They all have good posture, which they consciously maintain. They are future-oriented and very interested in the world around them. Most have experienced tragedies but live with an attitude of getting past the pain. They are all aware of the importance of staying mentally and physically active, and they make plans for lectures, parties, and time with friends and family. They don't want to miss a beat, and in a sense seem dedicated to giving back to the world. The bottom line for each of them is that they ignore their physical limitations and are determined to keep busy. Interestingly, none of them

expressed a desire to start life over. They have no regrets, and they look for and face new challenges daily.

I see the people I have photographed as messengers of history. In my photographs, I have tried to show their dignity and convey the message that these people are the treasures of our society, and they continue to contribute to the quality of life for others as well as for themselves. When I am asked why I do this, my only response is "I must." Although some of the people in this book are no longer with us, in my memory they have been my teachers, my mentors, and my friends, and they will always exist.

For me, this has been an adventure and a natural outgrowth of the days I spent in my grandmother's darkroom. Today, my granddaughters, Claire and Alyson, assist me with many of my photographs, and I see another generation feeling the magic I felt in my grandmother's studio.

TOO BUSY TO COUNT THE YEARS

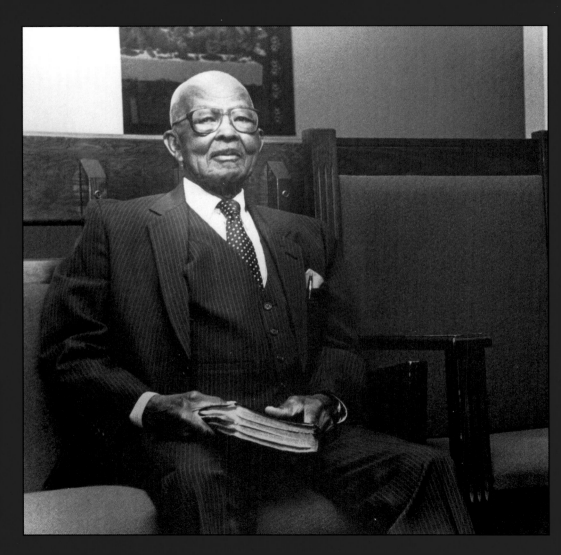

CECIL ADDERLY

My bible is as much a part of me as my wife of 60 years and my eight children. If you please God, He will give you a good life.

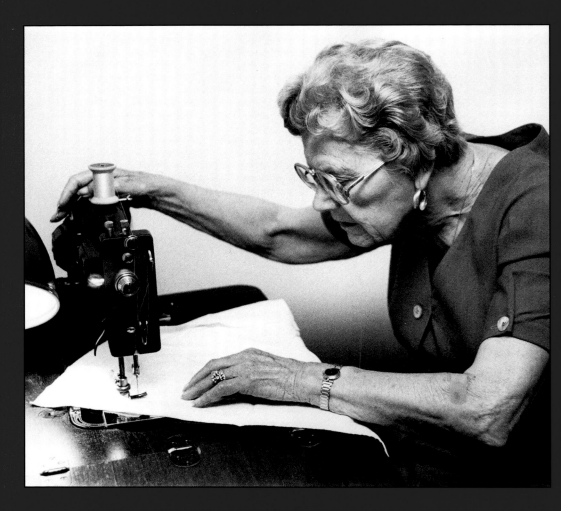

LOUISE BASSO

I went back to work as a department store seamstress at age 91. I am healthy because I never tell you my troubles.

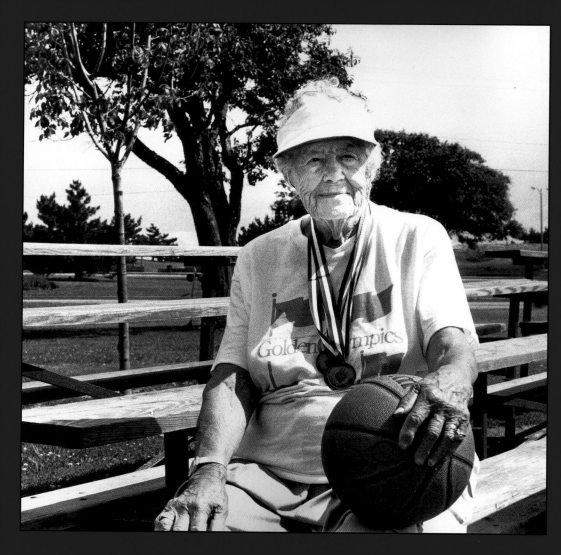

ESTHER CAWTHORNE

I'm in the habit of shooting baskets. In 1995, I was a senior medal Olympian in the Golden Olympics. There was no coverage of the games in the newspaper, so I marched myself down to the editor's office. Next thing I know, I'm on the front page of the sports section.

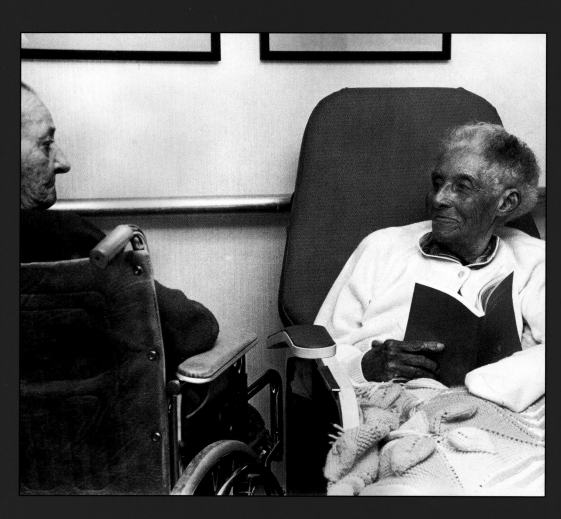

EDNA CHANDLER

Singing is in my heart. I am proud to lead songs for the retirement home. Help people, honey. You'll feel better.

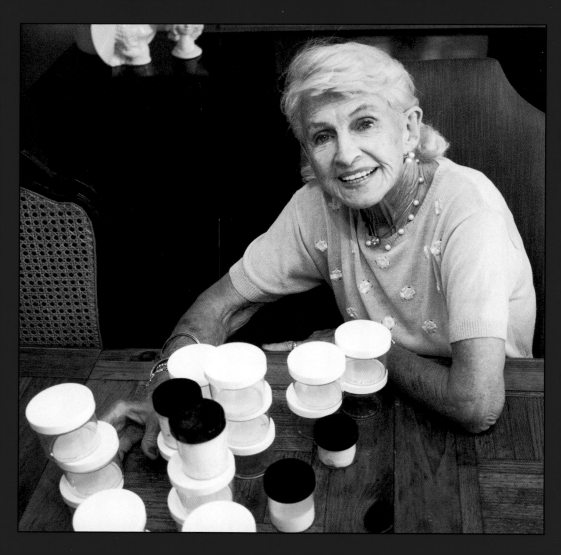

LEE SMITH CONDUFF

I have been in the beauty business all my life. My years of experience led to the development of my very own all-natural skin cream. I give this cream away. I love to make people look pretty as well as feel pretty!

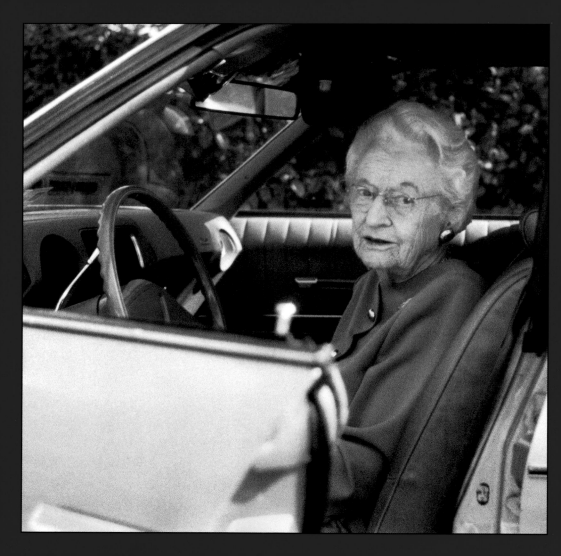

HOPE JONES DUKE

I am chairman of the Women of the Church. I walk up and down my stairs daily and still drive to all my meetings. Just leave it up to the Lord.

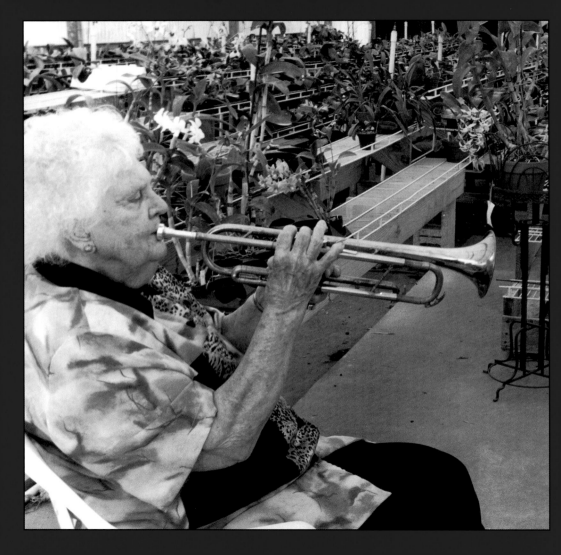

ELSIE DURGIN

I am proud of my large family. Poetry moves me, and I can still make a joyful noise with my trumpet. I always look at the bright side, though I am blind.

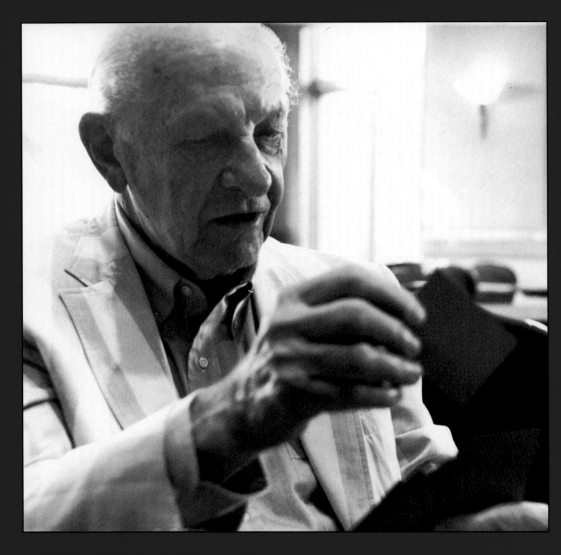

FELIX FERTIG

Y ou have to be honest and honorable all of your life. I don't worry about my age as long as I can play bridge and dance the night away.

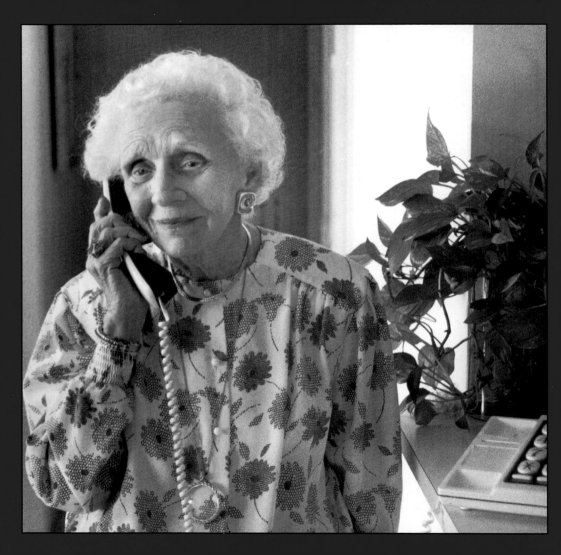

BELLE FINE

I am blind, but I can see forever.

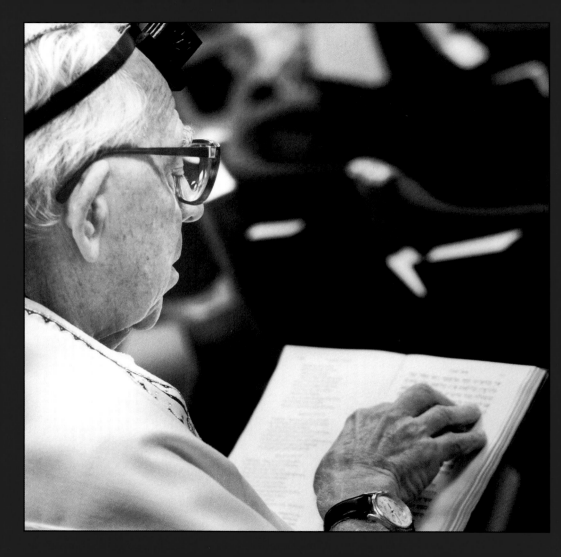

JOSEPH GORDON

I attend temple services every day. The discipline I receive with my prayers keeps me alive and well.

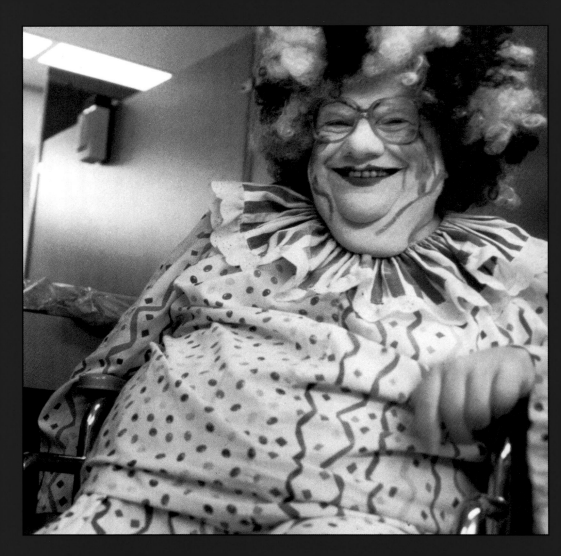

FRIEDA GROSS

After my husband died, I went to clown school to avoid being depressed. Then I had an accident and my leg was amputated. Now, I clown from my wheelchair and have found my calling. I can make people laugh.

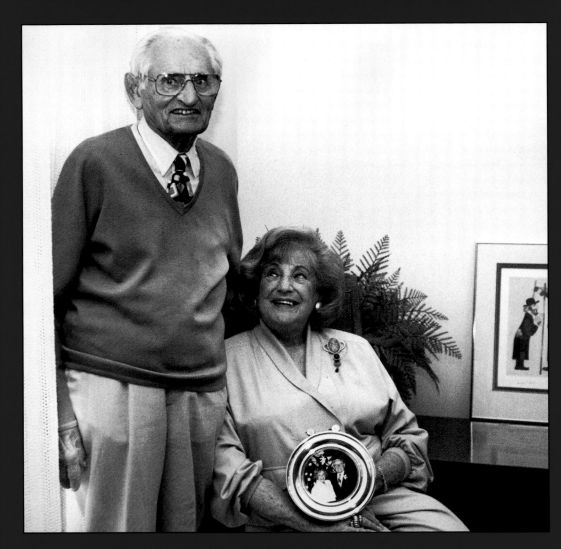

HERMAN JACK HALPRIN

In need of a dancing partner, I ended up spending 11 years trying to convince Harriet to marry me. When I was 93, she finally said "yes."

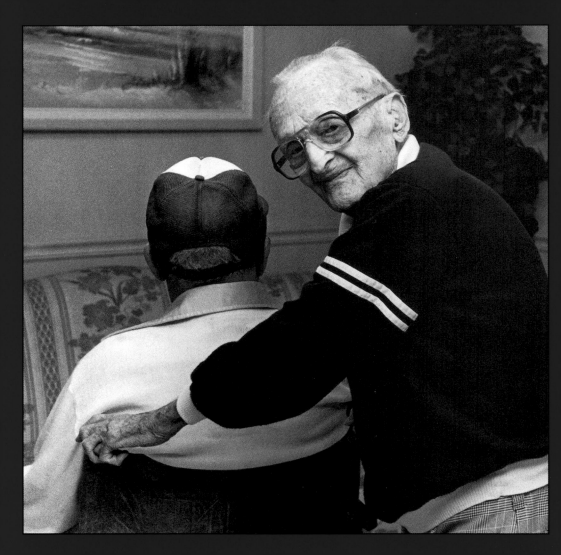

RICHARD HASKELL

I volunteer at a retirement home and take residents for their daily strolls. I have a hard time sitting still.

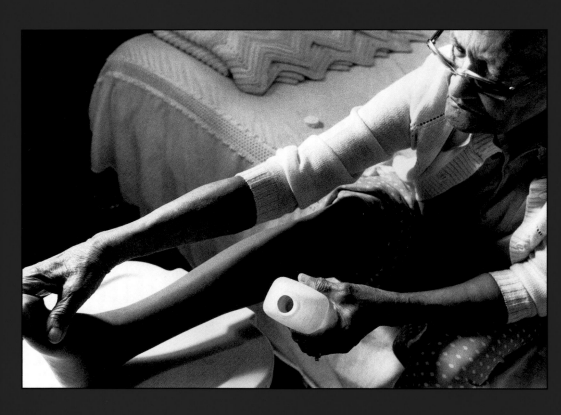

LILLIE MAE HILL

I am glad to be at the core of my family. I was raised in a Virginia orphanage, but I never let anything get in my way. I was the official seamstress for the bishop of the Church of Jesus Christ of the Latter-Day Saints. Sewing was not only my work, but a source of comfort and relaxation.

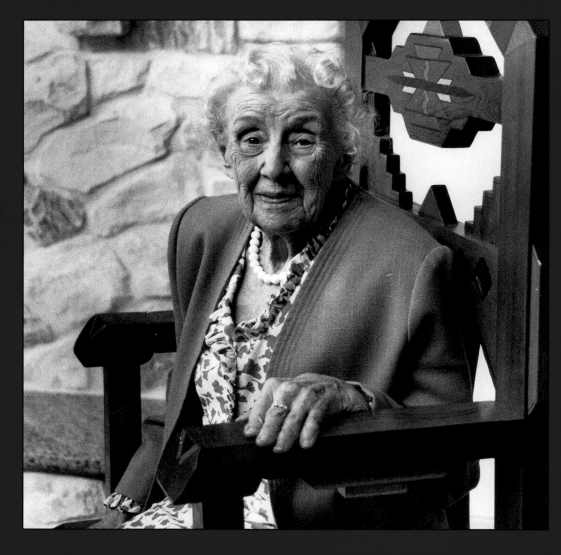

EDA HIRSHSON

I don't believe in doctors, but I do believe in luck. I take a nap every day. That's my secret.

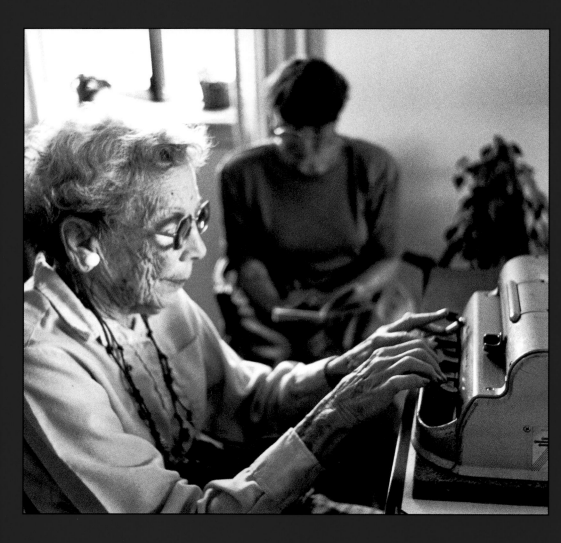

MARGARET HOFHEIMER

If you think old, you will be old. I take a million pills, but I think young. Throughout my life I have transcribed books into braille. Now, they call me the Matriarch of the Lions Club.

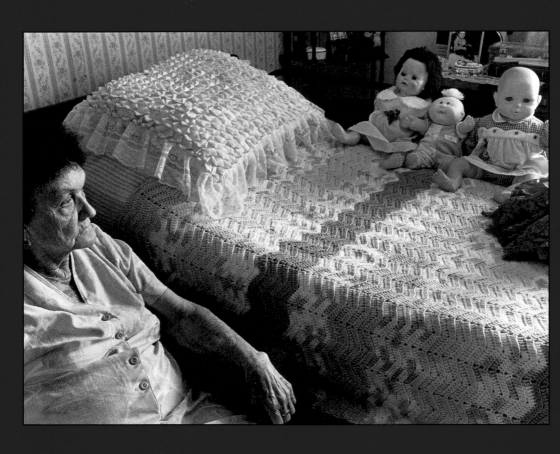

TRUE HOYLE

I am blessed by the Lord. When people I know need company, I give them one of my dolls. They give comfort and friendship.

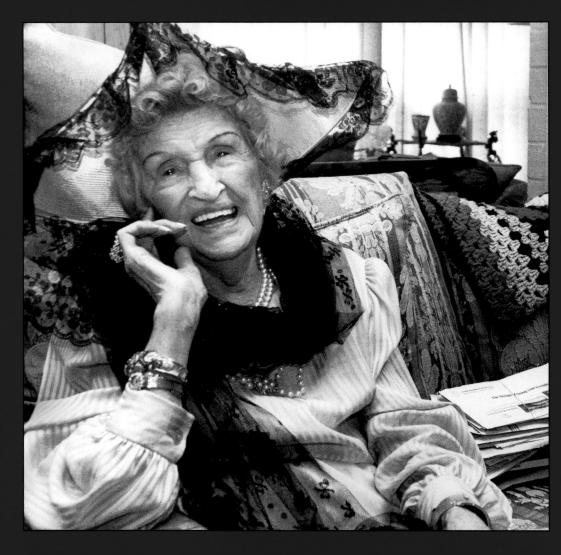

MAE BELLE HUNT

I am crazy about nature. I am crazy about everything pertaining to God. Life is sweet. Let's not rush it. Why have I lived this long? Well, I guess I am too busy to die.

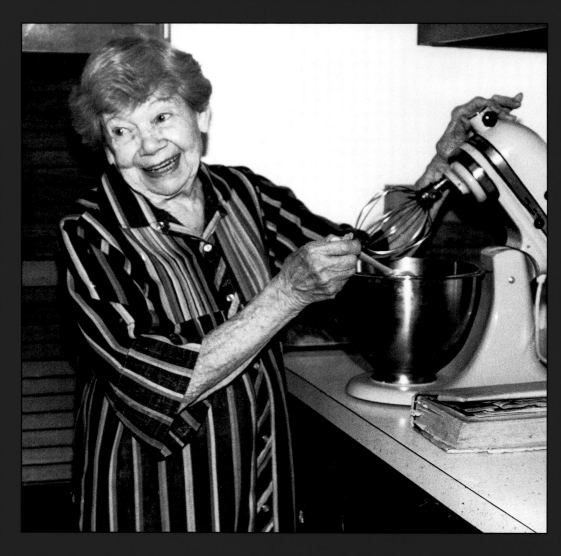

SARA ISAACS

I was born to cook. I love life. You'll never be lonesome if you always stay busy. Every day, I make a cake for a special friend or neighbor.

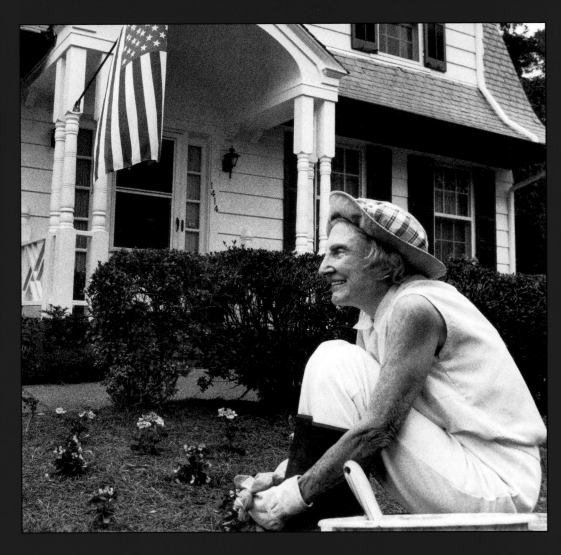

ROSEMARY JORDAN

I recommended that pets be allowed to live with their owners at Westminster Canterbury of Virginia Beach, a retirement community. It took two years to pass the board. Now three floors are designated for people and their pets.

I feel life is an exhilarating journey with unforgettable experiences awaiting.

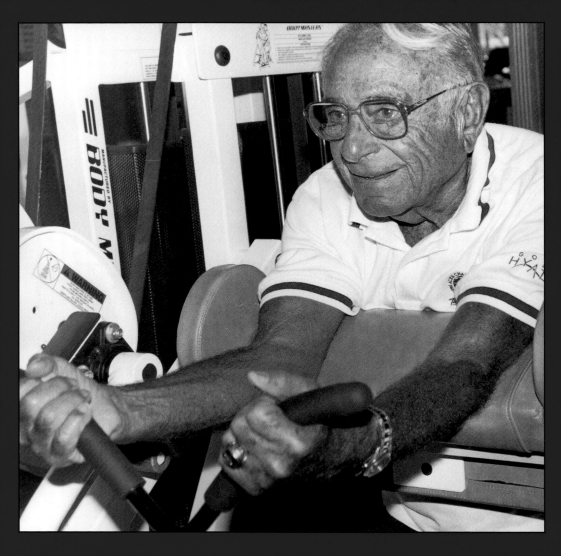

BILL KALIFF

I'm no athlete, but I have exercised all my adult life. My trainer says I've got great legs.

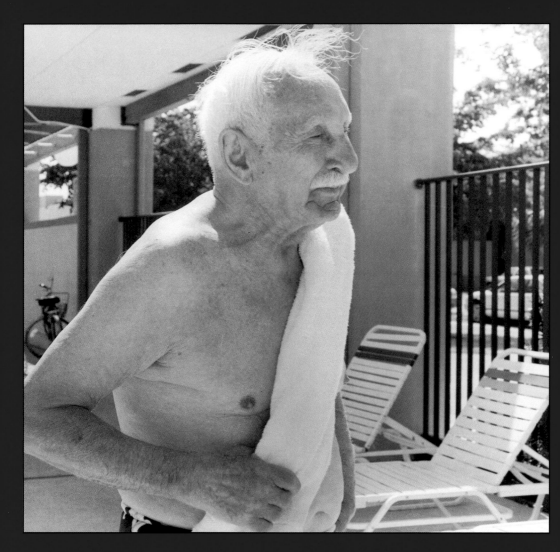

LOUIS KLERFELD

Good or bad, the sun still comes up every day. Take it as it comes.

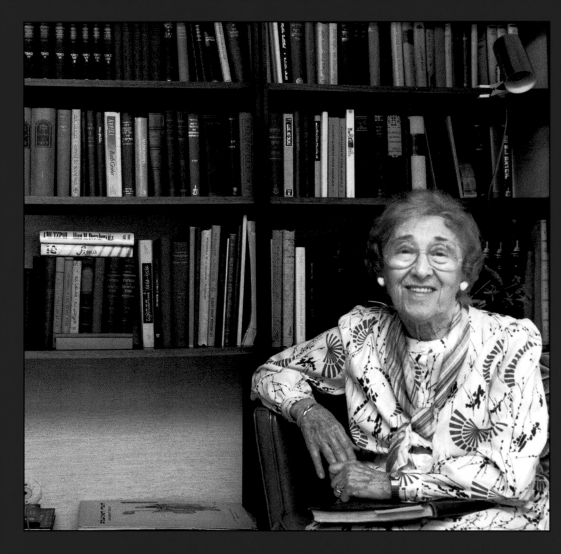

ESTER LaMED

My teachers were my angels. I have such great respect for them. They taught me to open a new door every day. I still get excited.

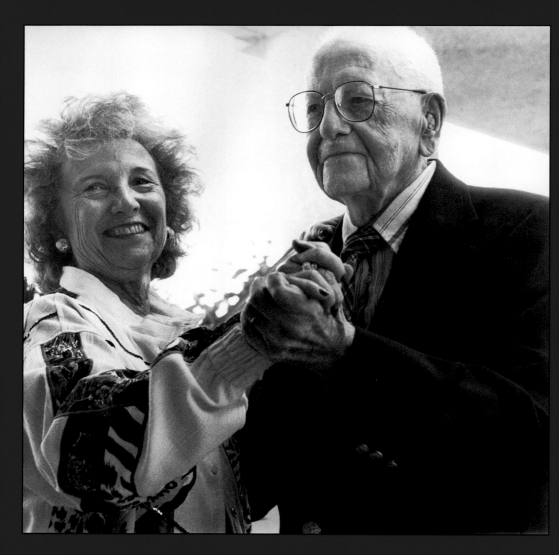

CHESTER LARSON

Every morning before getting out of bed, I wiggle my toes 100 times. I walk two miles each day and can still dance the waltz.

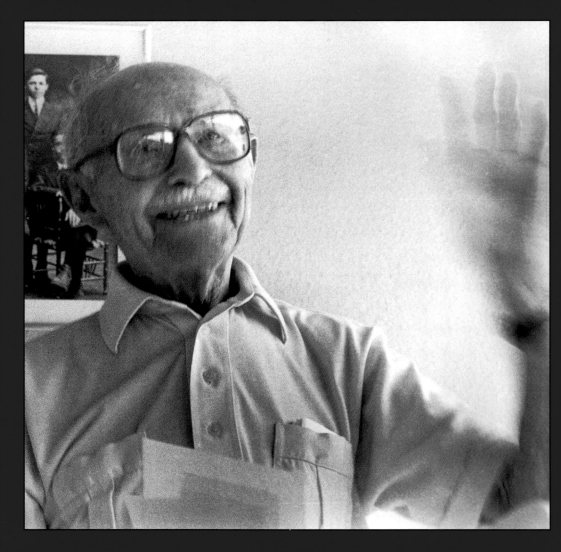

JACK LASKY

I often think of Woody Allen, who said, "It's not that I'm afraid to die. I just don't want to be there when it happens."

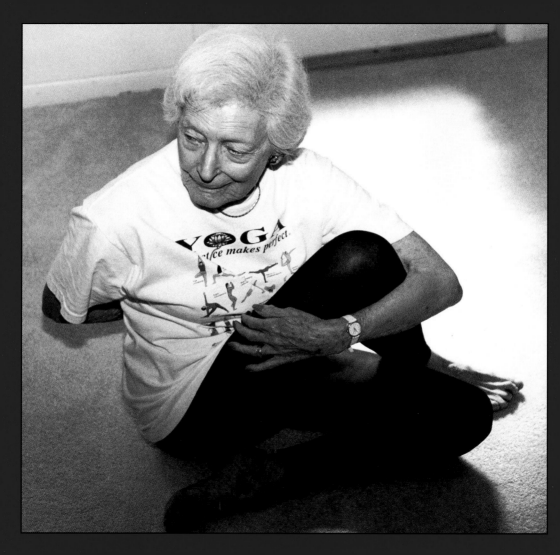

RETA LASKY

Don't waste time worrying about things you can't control. I finally got the hang of it at 90, and now I'm into opera, yoga, college classes, and music festivals. . . . Oh, yes, I am legally blind.

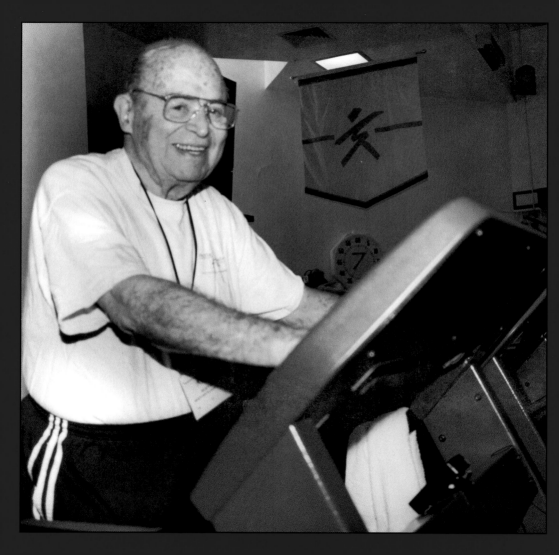

BERNARD MANISCHEWITZ

Bernie is the retired president of a famous wine company, and he attributes much of his success to public speaking classes. Bernie believes that even if you get sick, you should never lose your will to get better.

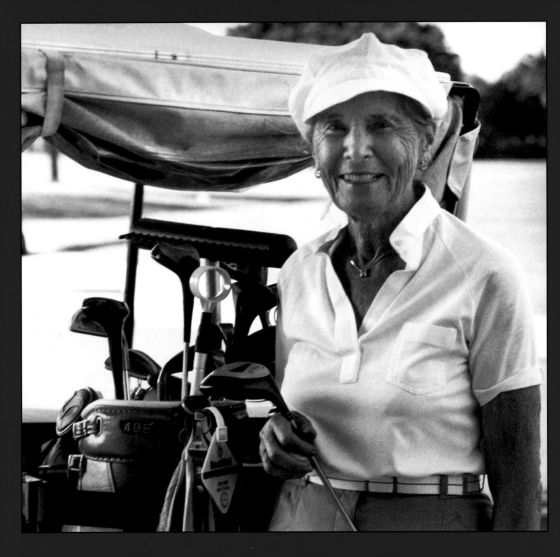

BEA MELTZER

Each person is a hero. Make your children your heroes. Yesterday is a canceled check. Tomorrow is a promissory note. Today is ready cash. Spend it wisely.

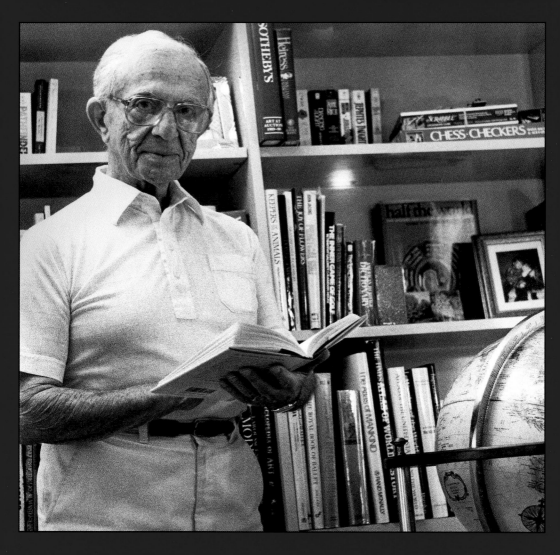

JOE MELTZER

In 1927, I photographed Irving Berlin. At age 62, I took the New York State high school equivalency test to earn my diploma and then went to Columbia University at age 63. My dimples tell the story.

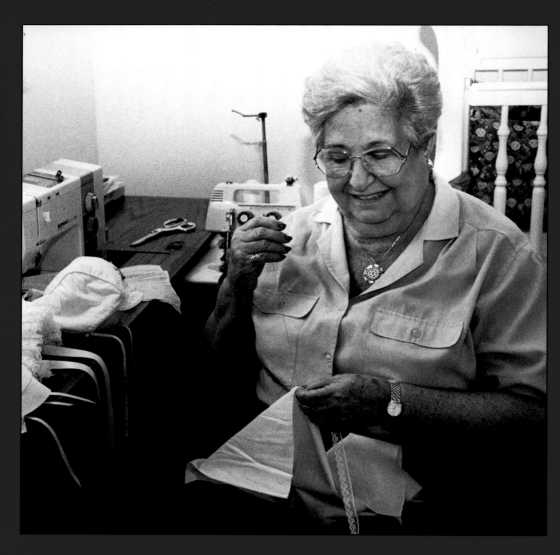

ESTHER MENDEL

My family was poor growing up, but we were rich in everything we did. I try to do twice as much for people as they will ever do for me. It always works out in the end.

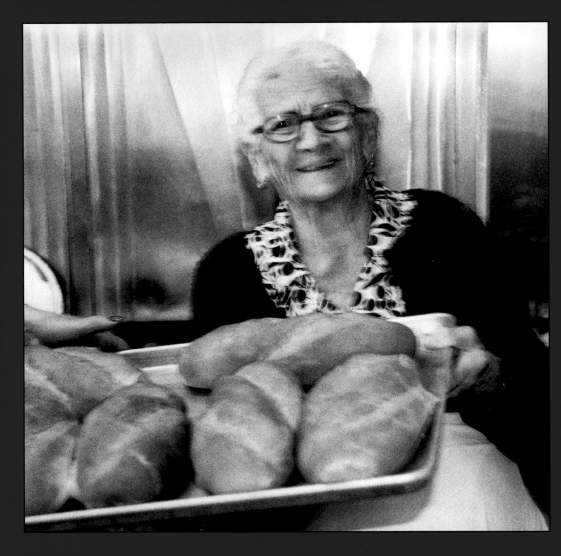

BARBARA MOUJAIS

If you stop work, you get sick. If you sit too long, your body stiffens and cripples. I bake bread, work with three generations every day, and am happy.

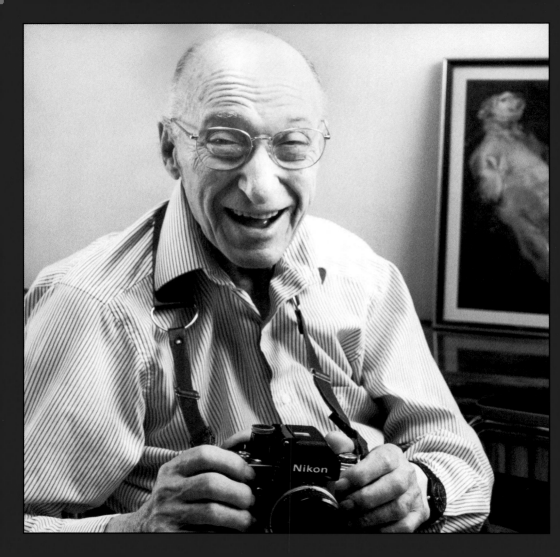

JOHN MULLER

My photography captures the art of truth. It offered me a chance to see the good and the bad throughout life. I still take great pleasure in it and feel good knowing I have passed my artist's eye down to my son and granddaughter.

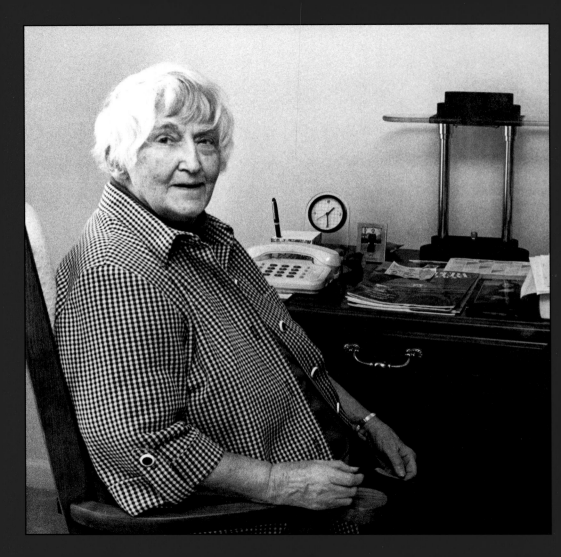

KATHRYN NICHOLSON

L ongevity? It's part heredity, part attitude,
part classical music.

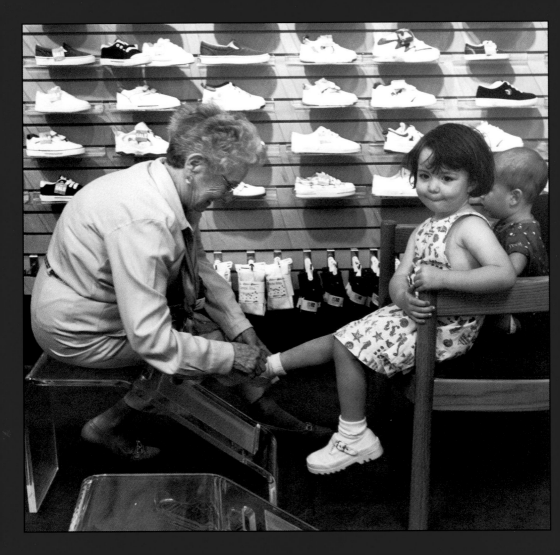

ETHEL NIPPER

I work four days a week at a shoe store where I am now fitting the third generation of customers. If I retire, I'll die.

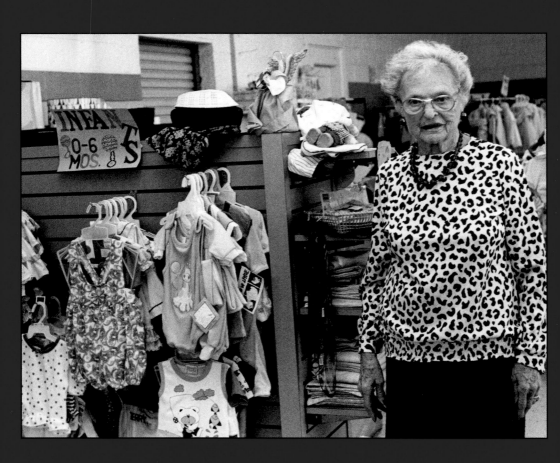

JUSTINE NUSBAUM

I've been helping people since I was 10. All I have to do is meet a person, and I am a dead duck. I can't help it. When I turned 90, my children opened Justine's Clothes Bank, a free clothing source for the needy. I work there every Tuesday.

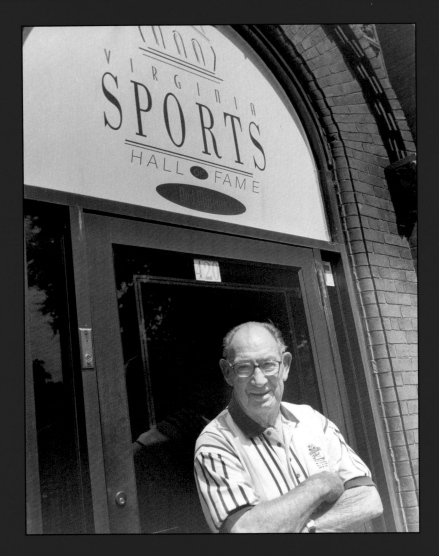

Clarence "Ace" Parker

My father taught me to never take advantage of others. If you are a better athlete, give the other person a chance. I have been elected to five halls of fame. I am amazed at how well I am, because I have had so many injuries. I spend my time playing golf and raising money for my alma mater, Duke University.

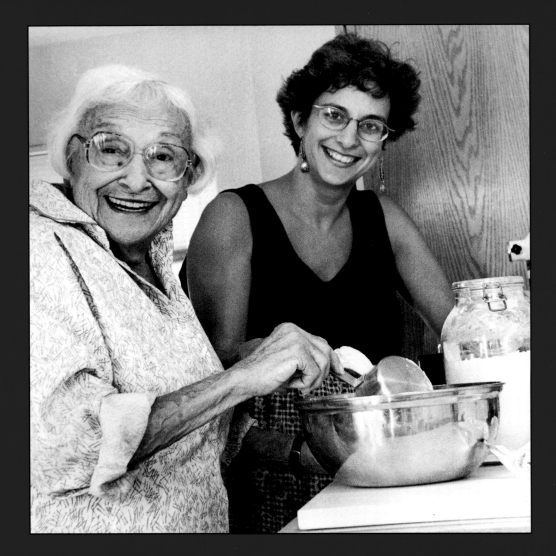

BESSIE PECK

Bessie lives next door to her granddaughter, Linda. They both enjoy the old-fashioned comfort of cooking and visiting with each other daily. "You're never too old to learn from the younger generation," she says.

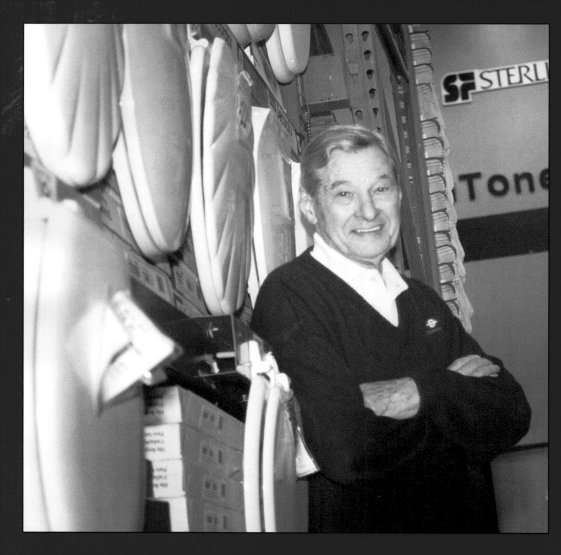

LEO PELLER

I call myself the "Compleat Plumber."
"Compleat" is an archaic way of saying
"complete." How's that for an old plumber?

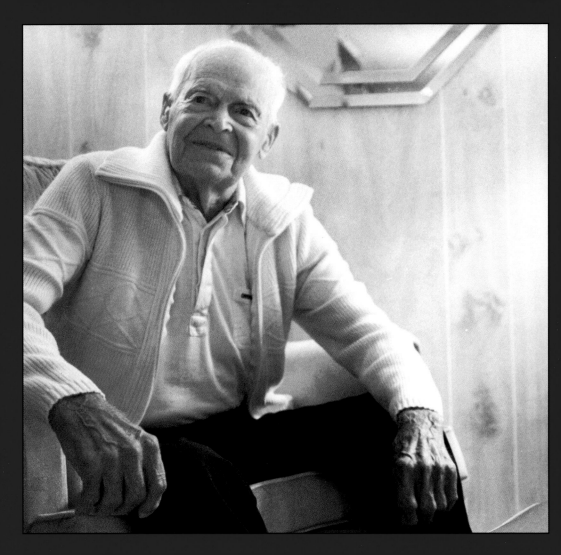

GEORGE PHILLIPS

I grow and eat organic vegetables. Vegetables and fruit juice are not only healthy for you, they put hair on your head.

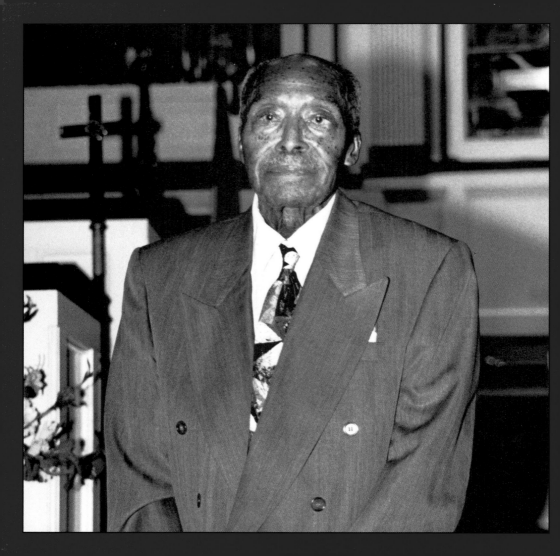

EDWIN ROGERS

I was a teacher. Always will be. I am now the oldest member in my church. It's just not my time yet.

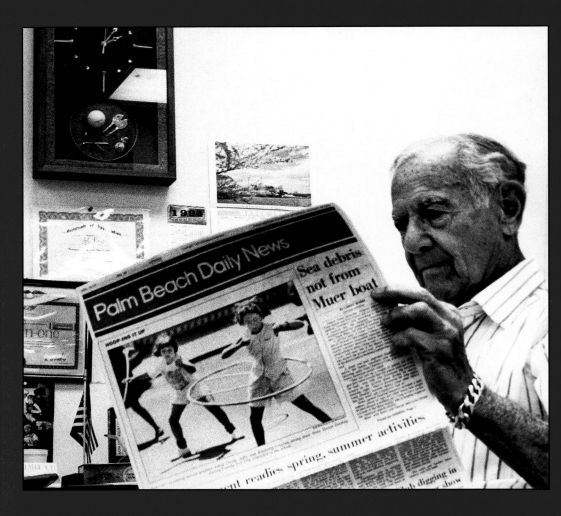

AL ROSS

I tend both mind and body. I work for the *Palm Beach Daily News* every day. Then I teach golf in the afternoons to handicapped people as part of a program I started for the city many years ago.

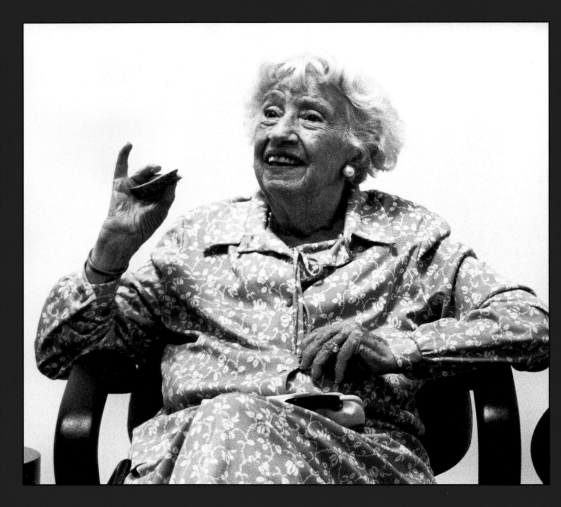

MATA ROUDIN

My doctor once told me I was living on borrowed time. I told him I have never borrowed anything in my life, and I don't intend to start now.

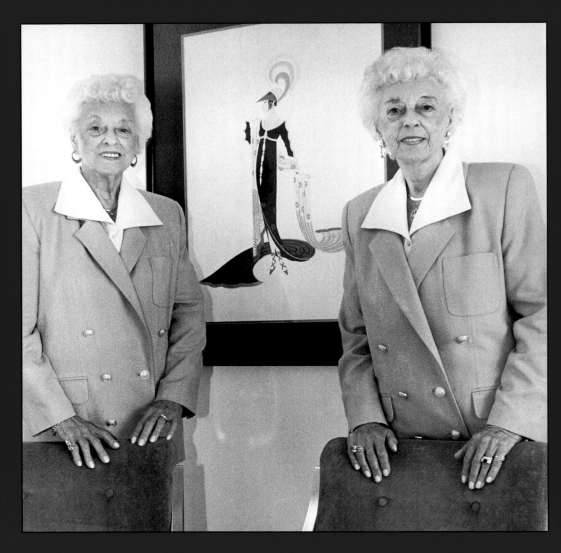

ROSE SAMELOFF AND BERTHA SUSSMAN

Our birthday is coming up. It's a big number, but we don't care. Powder and paint makes you look like you ain't. Just keep going.

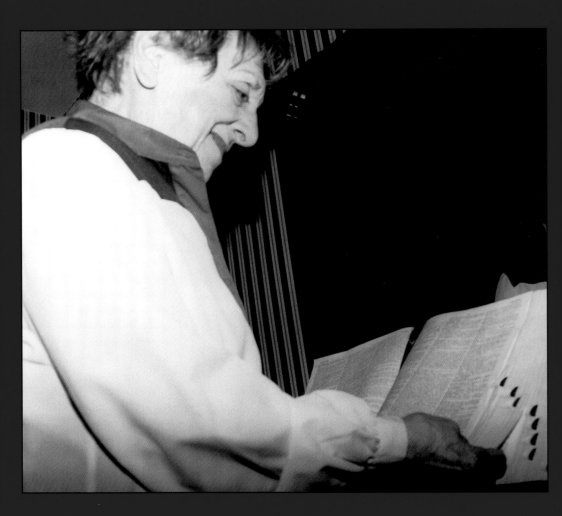

ROSE SIEGEL

Either I stand up straight and trust I've made the world a better place, or I don't go out. Who needs to stoop?

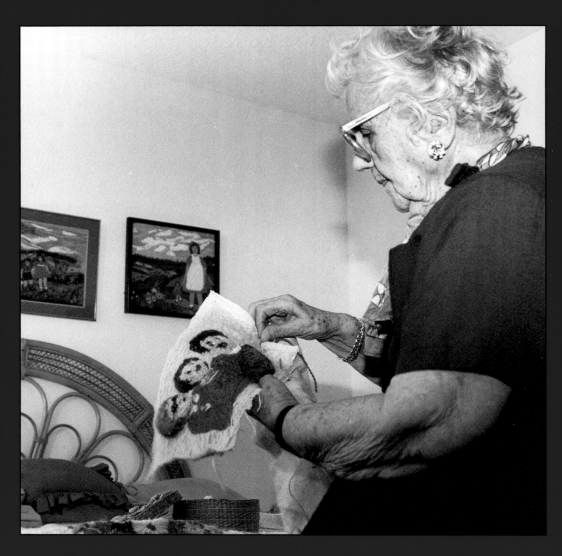

JEAN SIEGEL

I started college at age 70 and took an art class. At age 78, I had my first solo exhibition. There is no sense in keeping track of my age. I feel young.

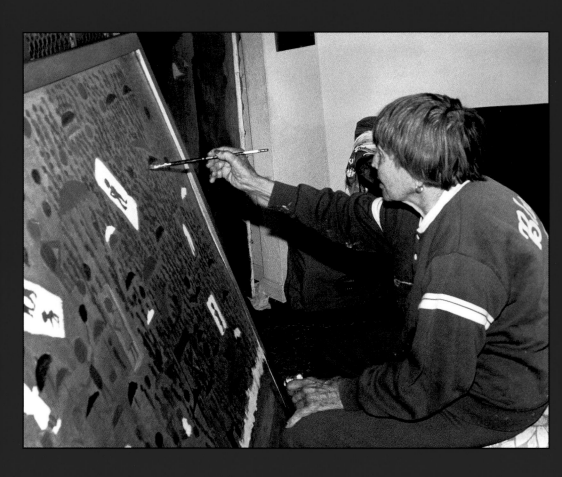

HELEN SINGLETON

I paint with an abundance of red hues. Red equals blood, and blood sustains life. I still paint every day. I don't know any better than to paint. It inspires me.

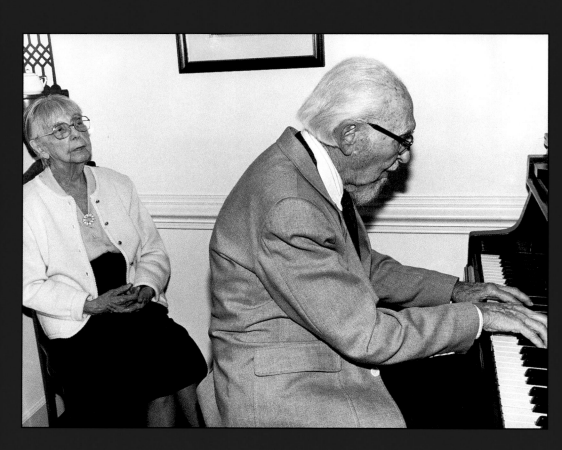

DAVID O. SMITH

My wife studied diet. That's how we got this far. After 72 years together, we just don't get mad at each other. She's everything to me.

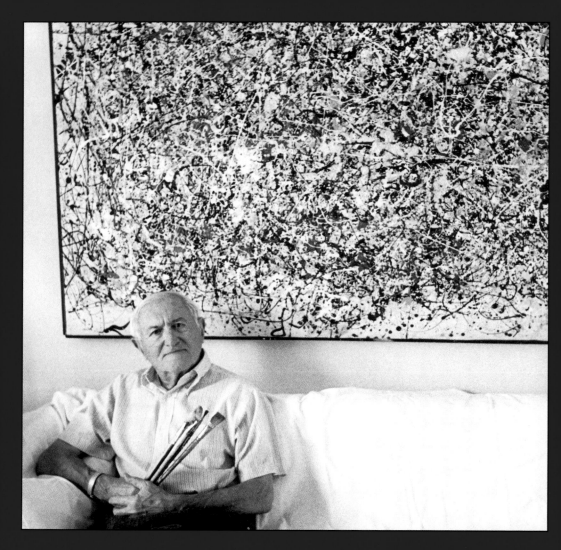

MILTON SNYDER

Embrace a hobby. I began painting when I was 50 and have never been bored in my life. There is too much to read. Each day, I welcome prayer and a few kisses from my wife.

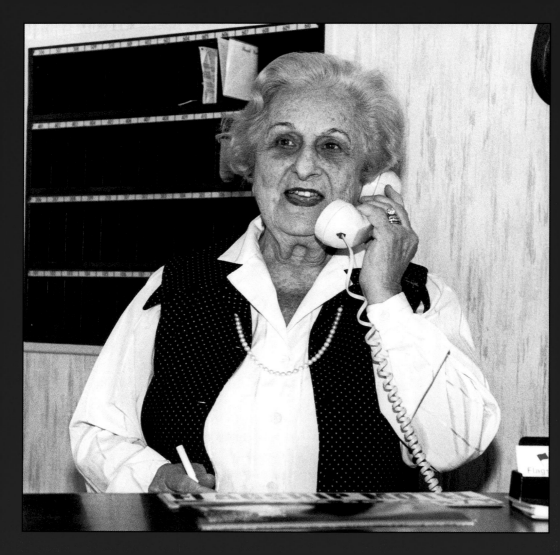

ELIZABETH SNYDER

Things always have a way of working themselves out. Maybe I feel that was because of my love of math. Or my positive attitude. My eldest grandchild credits me with teaching her the best of life's lessons and the secrets of a successful career. Whatever the case, I love helping with her business questions.

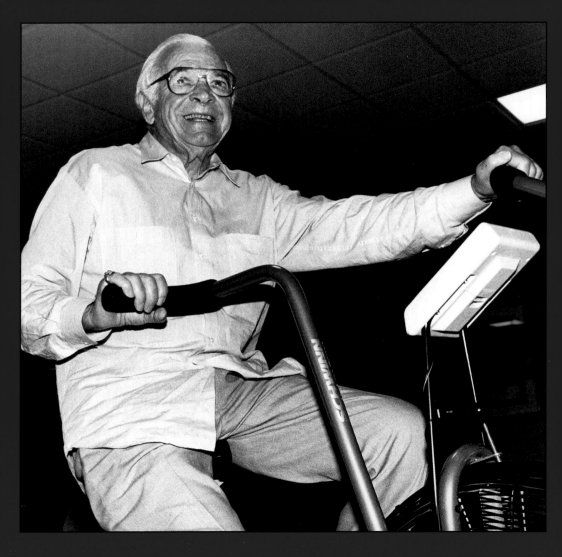

WILLIAM SPITZ

I've had a lot of excitement in my life, beginning in 1928 when I went to school in Israel and was almost killed by Arabs. These days, I relax with yoga and meditation. And I never eat sweets.

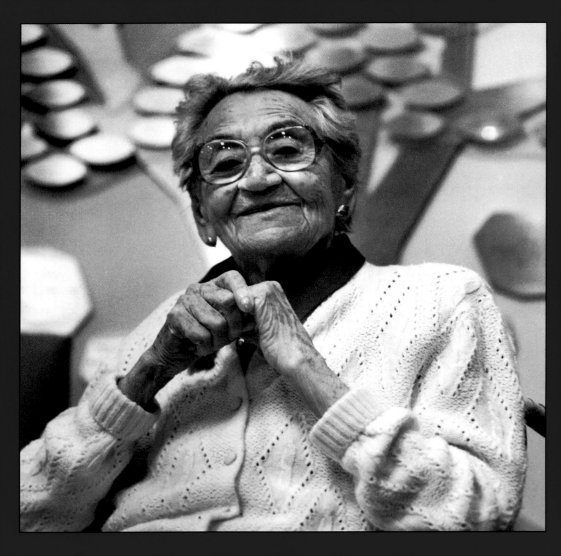

LILLIAN STOLLER

At age 85, I went to court for the first time. I volunteered as an interpreter for a Russian family with a traffic ticket. I made them laugh. Don't forget, it's all about feeling good.

HELEN THOMPSON

I scrub the floor every day for good exercise and teach quilting for fun. I don't go to church, but I can find religion just about anywhere.

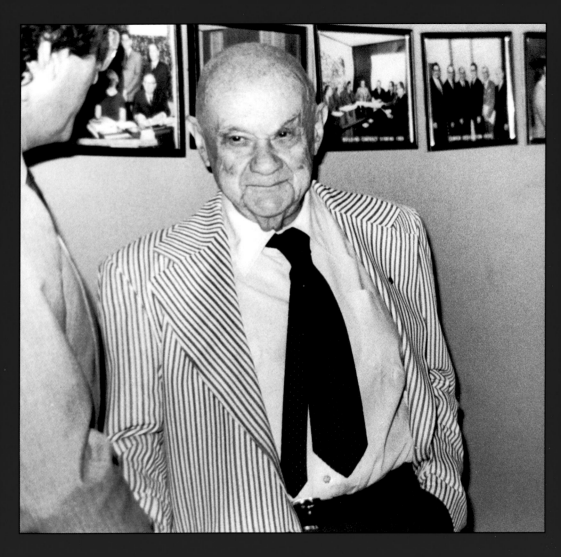

ROMAN VISHNIAC (1897–1990)

I was born in Russia. Photography was my passion, even though I had degrees in medicine and philosophy. I recorded the life of people from 1933–39. I was not able to save these people, only the memory of them. For six years I photographed with a hidden camera and sewed the negatives in the lining of his clothes. I was consumed with a desire to make certain this vanished world did not totally disappear.

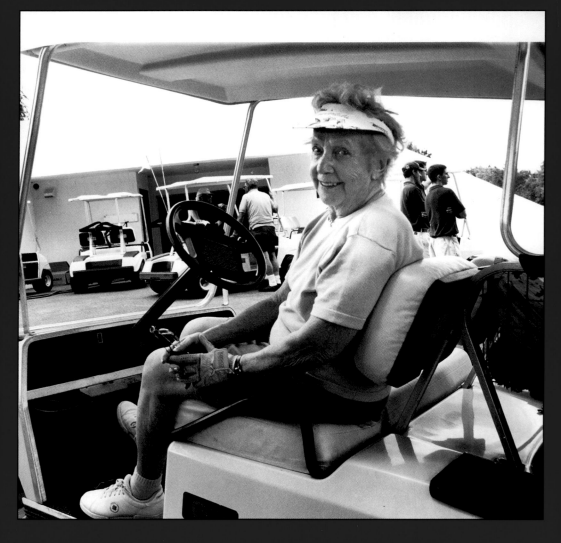

SARAH "SALLY" VISHNO

Sally lives in Connecticut. She plays bridge and golfs regularly with her children and grandchildren and says, "Catch up to me if you can!"

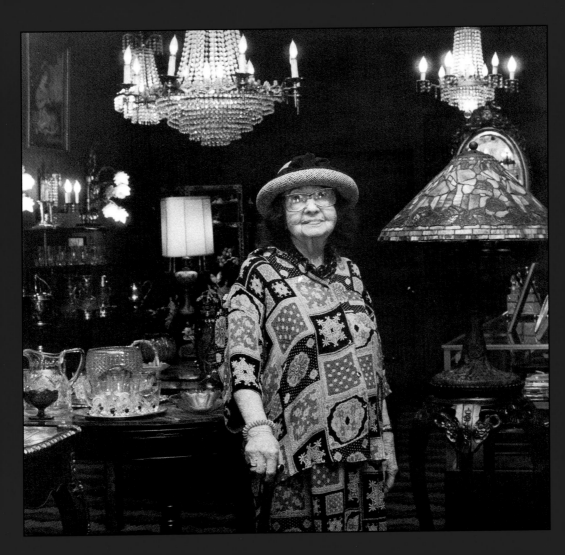

AN WEISS

I will outlast the competition. I own an antique shop in Dania, Florida, and have been selling antiques to collectors for three generations. When the best things are impossible, make the best of things that are possible.

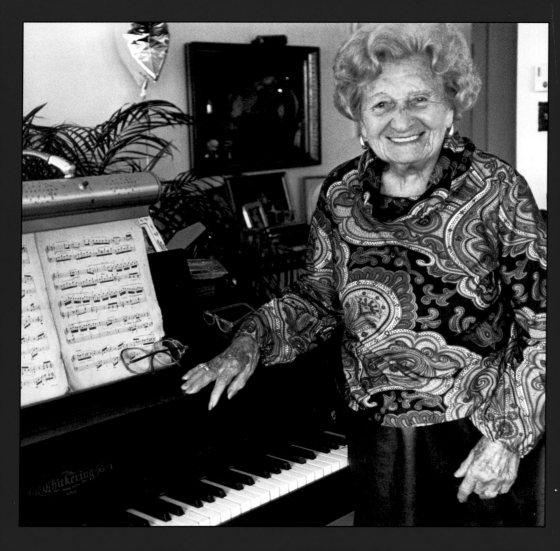

PAULINE ZFASS

God has blessed me with a wonderful family and good health. I can still play classical music on the piano daily.